T0065629

ORIGINAL POETRY & GENERAL LYRICS

Christian Poems

Franklin Rupert

WESTBOW
PRESS®
A DIVISION OF THOMAS NELSON
& ZONDERVAN

WestBow Press books may be ordered through booksellers or by contacting:

WestBow Press
A Division of Thomas Nelson & Zondervan
1663 Liberty Drive
Bloomington, IN 47403
www.westbowpress.com
1 (866) 928-1240

Because of the dynamic nature of the Internet, any web addresses or links contained in this book may have changed since publication and may no longer be valid. The views expressed in this work are solely those of the author and do not necessarily reflect the views of the publisher, and the publisher hereby disclaims any responsibility for them.

Any people depicted in stock imagery provided by Thinkstock are models, and such images are being used for illustrative purposes only. Certain stock imagery © Thinkstock.

ISBN: 978-1-5127-3849-0 (sc)

Library of Congress Control Number: 2016906409

Print information available on the last page.

WestBow Press rev. date: 6/30/2016

Preface

The beginning of the production of this little book on praise poetry began in the 1980s after he had gone hunting one day with a relative and said to him, "Do something special in life!" After stating this as the Months and years continued to pass by he'd think of what he had stated to his relative in a concentrating way until his thoughts started to begin to be organized in a creative way of writing them down for the purpose of improving humanity regarding people in life to be much more peacefully loving in a harmonious way. At first he could not retain his thoughts in his mind after these extraordinary thoughts began to come alive in his memory. Therefore, he said to himself that he should go and purchase something to write with and a tablet and get on a bed and start writing. After he started writing the organization of his thoughts began to come to together in a flurry. And after he had wrote poetry for a whole day while lying on a bed from after sun-up to sun-down making it a total of Three days to finalize only the beginning foundation for a life of successful praise poetry writing.

With this certain urge he wrote another Fifteen Thousand word book that were lost and a short proposal that he still have along with the same basic purpose of different kinds of creative ideas in order to accomplish all of these things prior to writing the praise poetry which were written last.

After starting and continuing to quote his praise poetry, not only to himself alone, rather also in the public, to individuals and groups of people whenever he goes for walks, and wherever he travels to. After quoting his poetry to them, they would always say their sounds is very good and that they enjoyed my poetic praises. Paul and his wife Christine recommended that I should have them sat to musical lyric songs.

After meeting his new friends; Minister of Emanuel Baptist Church, Carl Johnson and his wife Rolanda, and children Arriana, and Macy, and having been honored by him likened unto a Prayer Minister on November 4, 2014. It may have helped given him his new outlook on moving forward in the Ministry of prayer praises as a praise poet, and also in other needed Ministry areas according to being a Chemist.

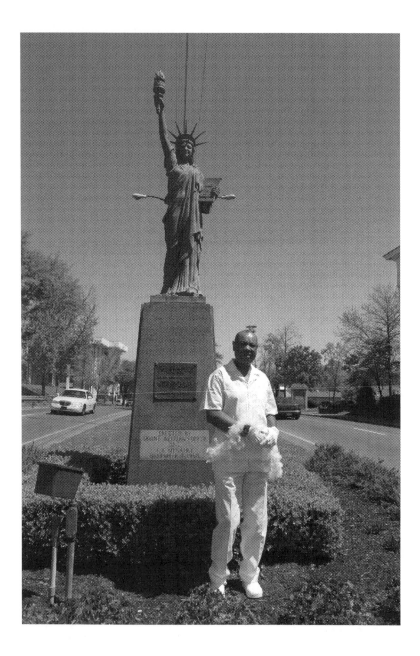

You are our mighty tower

It is through you that we have power

You are so bold and not a coward

Your fountain is sweet and never sour

We love to spend our time with you

You show more company than a crew

Take us into your arms tonight

Come and take us out of their sight

Together we will discern the times

Mine will be yours and yours will be mine

Amen

We are riding on the wings of time

We are leaving all of our troubles behind

We may not need a clock

Since we are never going to stop

When we really look at it

We sees that it is true

It is the reason we enjoys the morning dew

We do not save souls, Jesus will do that

We simply make broken spirits whole

By being twice as nice in introducing the confused to Christ

Do not disagree with the wise

Let us agree and get our heavenly prize

Amen

Write our names
Write them above
Write our names in words of love
Write our names
Seal them in gold
Our written names will save our souls
Write our names since we are ruddy
Write our names in words of beauty
Write our names in the book of life
That will be so very nice
Amen

May we give to you this get-well greeting

We had such wonderful Sunday- School meetings

We missed you so much hope you get well soon

Maybe we'll see you next Sunday by noon

Jesus will keep you in all of his ways

Like us you believe that prayer pays

Trust in Jesus all of your stay

He is a great healer each night and day

Amen

If you are age 5, 10, or 15

Ask for advice along with your dreams

Be careful in challenging a most distinguishing world

It is a way to live and not to have to die

Talk with a Christian and you will be told how

Do not sneak away from your parent home

When bad things happen others leave you all alone

Amen

Hug us, hug us, hug us, hug us

Please us, please us, please us, please us

Love us, love us, love us, love us

Keep us, keep us, keep us, keep us

Amen

Be our friend through thick and thin

Be our friend until the end

Be our friend and do not sin

Be our friend again and again

Amen

We are so very brave
More braver than any grave
We make death and hell behave
We who spare and we who save
Amen

Keep in touch don't lose contact

Keep in touch until we get back

Keep in touch don't lose your way

Keep in touch each and every day

Amen

The May wind blows as dandy-lines grows

Pomegranates turn yellow

Honeydews tastes mellow

You made them it is all so true

None of them is good as you

AMEN

We bless your name

We bless it good

We bless it throughout the Neighborhood

We praise your name

We lift it up

As we sniff a butter-cup

As we leave our troubles behind

We bless your name in all of Zion

Amen

We do not make consequential mistakes

We get in touch before too late

Before we ask you for a mate

We pray help us keep our Faith

To be in place to do your will

To tear down and to build

To open a door for the poor

To cleanse a wound to the core

To brighten up a darken path

To share a love that will last

Amen

We have some wonderful friends

We stick together through thick and thin

We talks about the way life should really be

And hopes the rest of the people would see

How we should give our lives to God

Or ever punished by his rod

Something he never meant to do

After sending his Son to make us new

Amen

We see you

We hear your precious voice also

Thank you for coming where we are

We really do believe in you

We trust in you for real

You are the most beautiful sight to us

You are more precious to us than gemstones, and we like gemstones

You are much more precious to us than diamonds, gold, or

anything else that we can see

We love to keep track of you

Watching the wonderful things you do

We even knows when you are near

It is then that we rejoices

Most of all we are waiting for you to return upon your beautiful

white horse

Amen

A friend in need is a friend in deed

The love you share separates us from greed

We love you no matter what you do or say

You loved us before we learned to pray

Thank you for feeding us with good nutrition

Your love redeems us from the son of perdition

Talking with you is what make things right

You get us safely through our dark nights

Thank you for all of your loyal days

Teaching and guiding us to walk in your ways

Amen

When times seem hard just pray a little prayer

It may seem hard but it is fair

Let us talk with Jesus, the one who really cares

All of our burdens he strongly bears

The world is the Lord's and the fullness thereof

No need hang our heads and sob.

Let us keep on pressing to that high mark

We can be like David when he carried the Ark

Amen

Turn to the Lord a listening ear

Call upon Him and He will hear

Because His love is truly dear

You have our words, don't doubt at all

Trust, and listen for His call

His Son paid the price for all

One day upon a weary cross

Amen

Give, give and do not doubt

Give some more and you will never pout

Trust, trust, you'll never be afraid

Trust the Lord coming to our aid

Lets lean to the Lord for understanding

Peace, be still, don't be demanding

Amen

Enter dear friend into His rest

Stop putting yourself through such a mess

Before young birds have ever left its nests

They depends on the stronger ones to meet their requests

Let us be wiser than serpents and harmless as doves

Let us keep our minds sat on things above

Amen

Joy is the key to happiness
It is not all in the way that we dress
If we says we love Him then let us give Him our best
Many people will know what we are about
When we show there is victory over doubt
Through the great loving Son of God
He commands us to love Him with all of our hearts
Amen

Thank you for creating us in your image

You did it with love and not with menace

Thank you for charity for one another

Along with love they both is our cover

By the word of the Lord we all must be govern

Thank you for gathering all of your sheep

The goats had kept budding and making them weak

We are happy our shepherd has returned

Now we are comforted and won't need to burn

Amen

A covenant of peace has come from the east

Oh! Come, everyone let us go to this feast

Sing aloud all people and clap our hands

Let us come together and praise Him in bands

It doesn't matter about our imperfections

Let us rejoice in bringing our souls under subjection

We will be glad when they ask us to pause a few minutes

Since we are supporting a heavenly cause and winning

Amen

Lord, please equip us for this battle

No need whip us with your paddle

We give honor where honor is due

We spread good news because of you

So when life here comes to its end

We know through you life will begin

After we've become the way you are

You will give to us the Morning Star

Amen

One day we met a gentleman with a leap in His walk

The amazing thing about Him were to hear Him talk

He talks about life in such a special way

Surely, you would be glad to hear Him say

My love runs deep and my love runs wide

My love is all-ways by my side

My love dwells in my heart and in my mind

My love is never left behind

My love gave to me a brand-new start

My love gave to me a place, in my heart

My love is better and my love is sweeter

My love is all-ways a one-way street

My love stays with me all day and night long

My love is now helping me to sing my song

Amen

Those going through do needs our attention

Silence becomes rejection when it is failed to be mentioned

After it is made known now we can take action

So life won't become a living disaster

Obedience to Jesus' commandments

Respect and honor to parents is our new friend

This is the road to freedom again

Amen

Come into our hearts today
Come into our hearts and stay
Fill us with your precious Joy
Man, woman, girl and boy
Amen

Matthew 7:17 Even so every good tree bringeth forth good fruit.

Come to me

Come to me

For I am yours O can you see

Come to me

Come to me

For I am sparkling with eternity

Come to me

Come to me

And you will all-ways be with me

Amen

Printed in the United States
by Baker & Taylor Publisher Services